THE ART OF OMAR LAMA

Black and White Master Drawings from 1966-2006

Sunship Press
Chicago, Illinois

Copyright 2014 Omar Lama
All Rights Reserved

No part of this publication may be reproduced or used in any form or by any means-graphic, electronic, or mechanical, including photocopying, without written permission of the publisher.

Front Cover: Omar Lama-Self Portrait
Back Cover: In the Rain - Self Portrait

CONTENTS

Page
- 5 - Introduction
- 7 - Tree in Winter
- 8 - Zebra
- 9 - Jesus
- 10 - Butterfly
- 11 - Miles
- 12 - Jazz Lives
- 13 - Coltrane
- 14 - Blues Man
- 15 - Pharoah Sanders
- 16 - Stevie Wonder
- 17 - Roland Kirk
- 18 - Otis Redding
- 19 - Invisible Musicians #1
- 20 - Invisible Musicians #2
- 21 - Design #1
- 22 - Terry the Jazzy Writer
- 23 - Design #2
- 24 - African Dance
- 25 - Bamboo in Wind
- 26 - Design #56
- 27 - Antelope Heads
- 28 - Elephant
- 29 - Mother and Child
- 30 - Darlene Blackburn
- 31 - African Mask

Page
32- Lady with Jug
33- Portrait of Judy
34- Bantu Queen
35- Fertility Doll #1
36- The Flag
37- Fatu
38- Fertility Doll #2
39- The Conquest of Self
40- The Sidewalk
41- Yin and Yang
42- The 4 Seasons
43- Monk
44- Jazz Horn
45- Sonny Rollins
46- Roland Kirk
47- Fertility Doll #3
48- Eye of God
49- The African Head
50- African Sculpture
51- Cosmic Cycles
52- Baraka
53- Wind Chimes
54- The Center
55- Eyes
56- Design #13
57- Wheel of Karma
58- Roots

INTRODUCTION

I have known Omar Lama (John Porter) for the better part of 40 years. I actually met him before I knew him through his work. Omar Lama's drawings were ubiquitous during the exciting Black arts movement of the late 1960s and early 70s in the African American community. He was one of the chief voices of the movement, due, in part, to his unique line drawing technique. Omar's work is as lyrical as a John Coltrane riff or a Thelonius Monk arpeggio. He does with his pen what a great poet or musician does with the tools of their trade. He has literally captured frozen sound in the poetic sweep of his pen, which lends credence to the title given to this collection of drawings - Black and White Master.

Omar was born on November 23, 1942 in Halls, TN. His parents migrated to the Bronzeville community in Chicago in 1945 when he was three years old. At the age of 13 he received a scholarship from the R.R. Donnelley Printing Company for 2 years of study at the Junior School of the Art Institute of Chicago.

Later he majored in Commercial Art at Dunbar High School in Chicago, and still later he majored in Studio Art at Kennedy-King College and Chicago State University.

Omar was a founding member of the art collective known as Africobra of Chicago. (Africobra is short for "African Commune of Bad Relevant Artists"). This renown collective has been exhibiting throughout the United States for the past 40 years.

Omar has been distributing reproductions of his drawings since 1966. This book provides an excellent sampling of his works. Enjoy!

Yaounde Olu, Ph.D.
2014

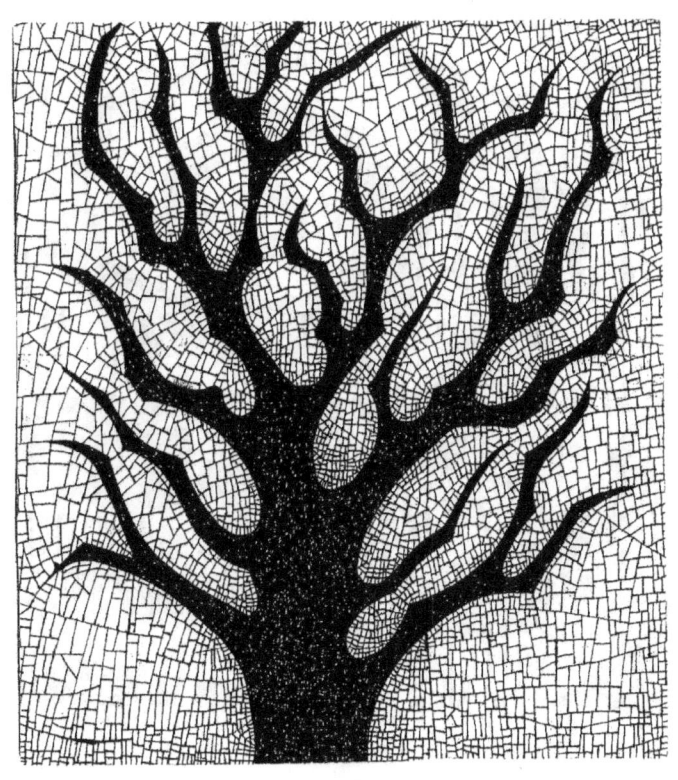

Tree in Winter

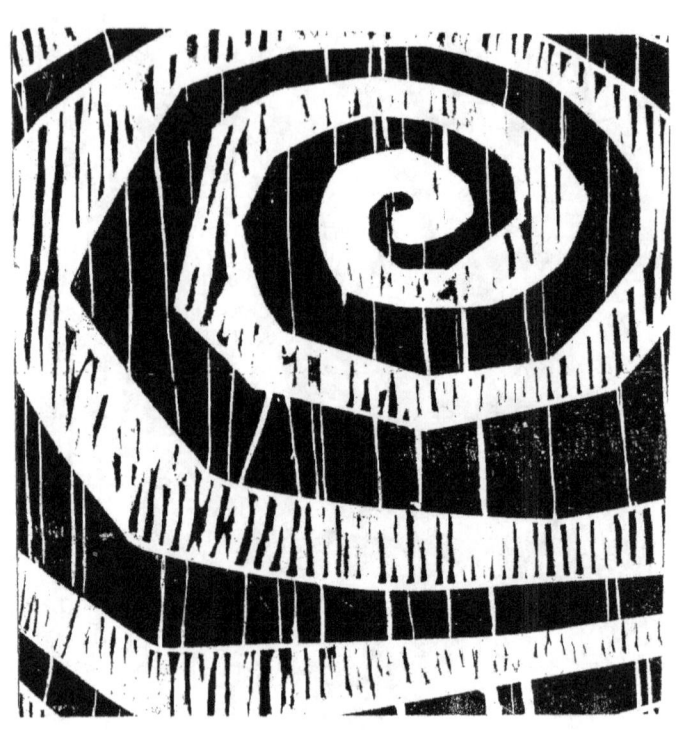

Zebra

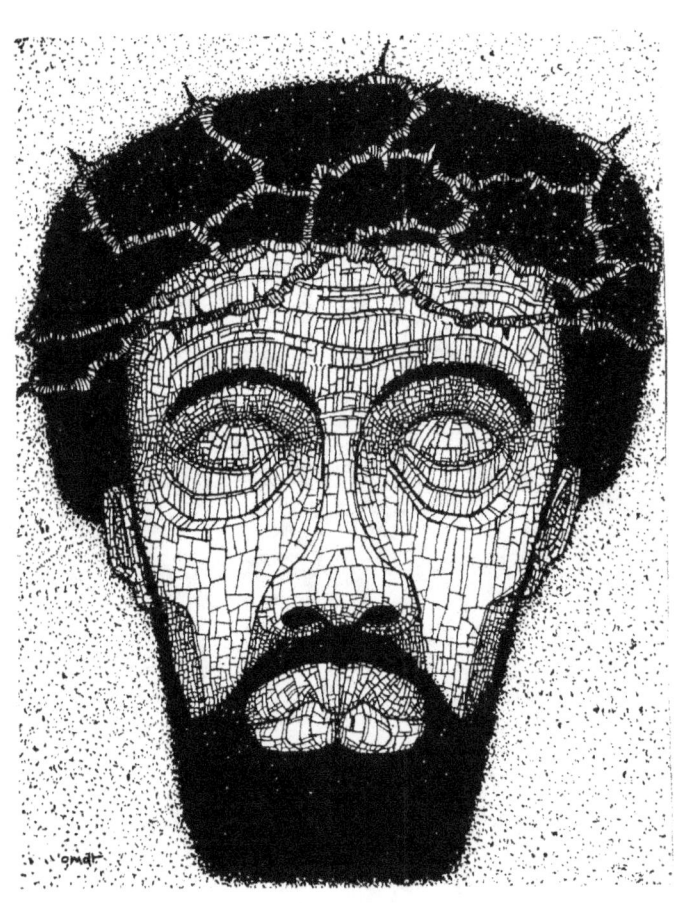

Jesus

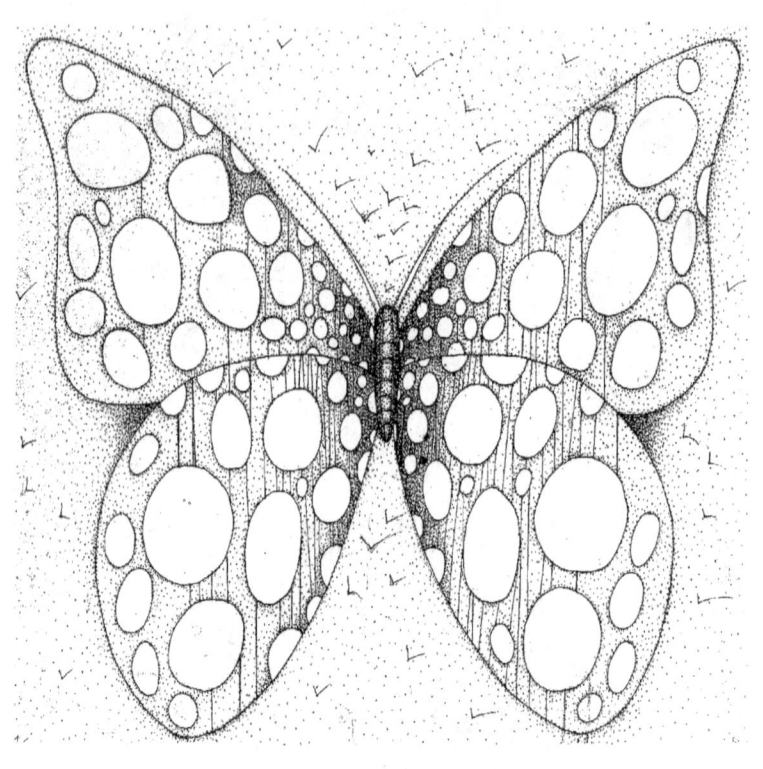

Butterfly

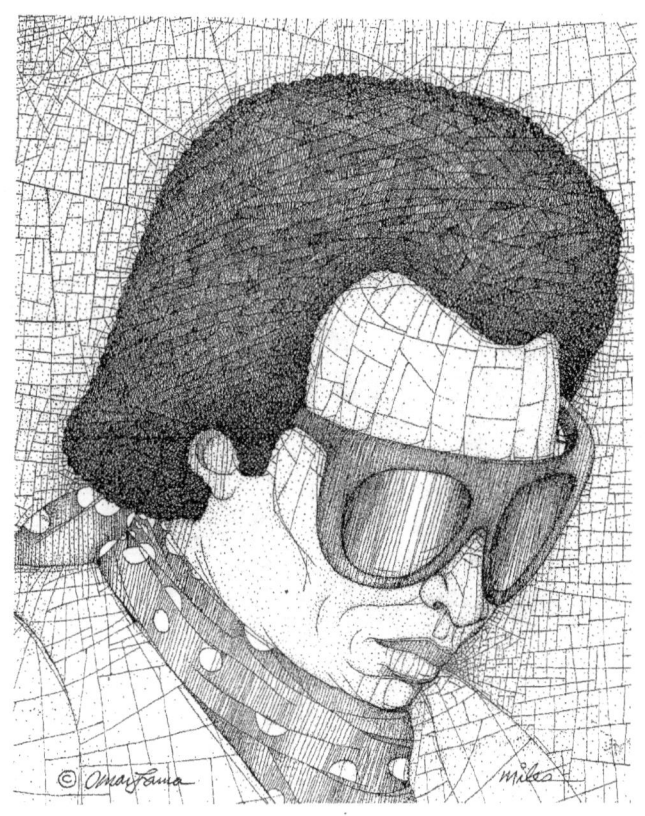

Miles

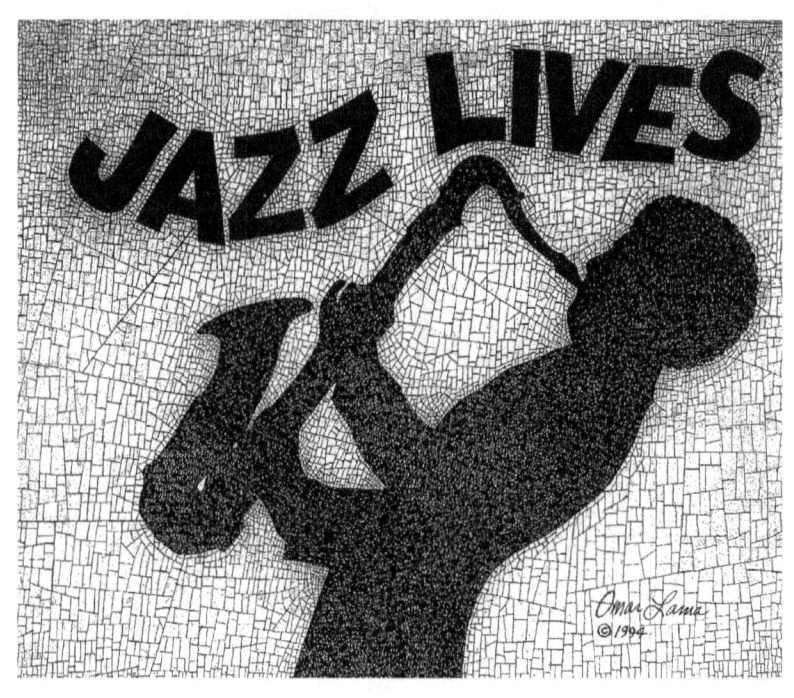

Jazz Lives

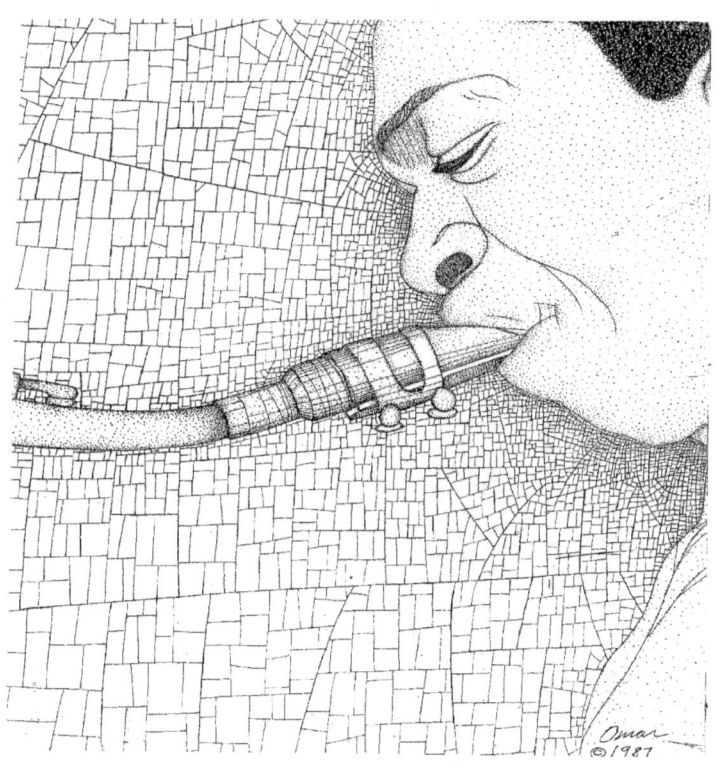

Coltrane

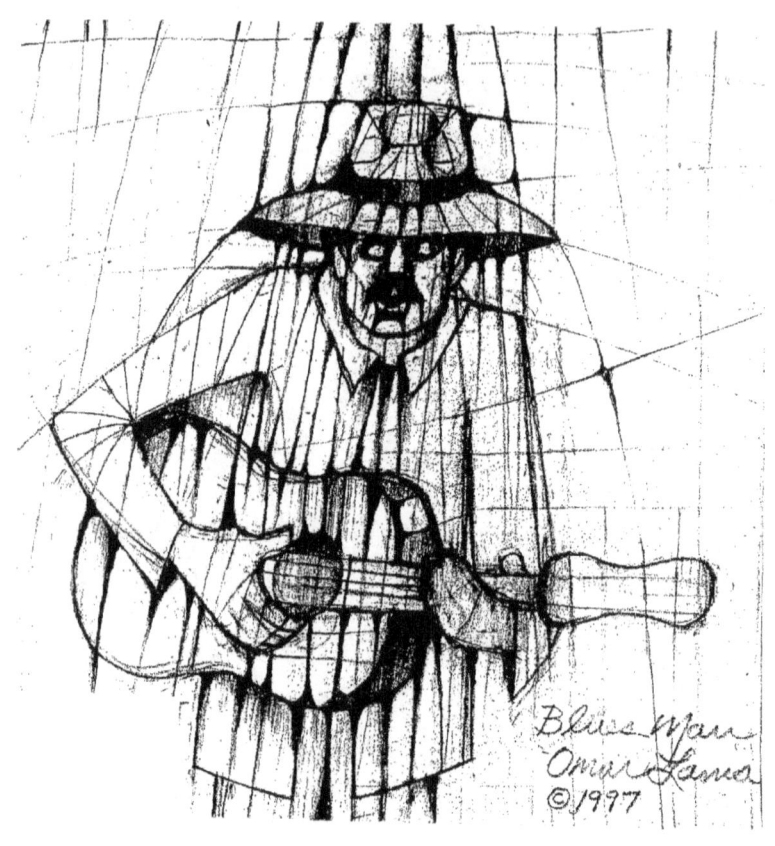

Blues Man

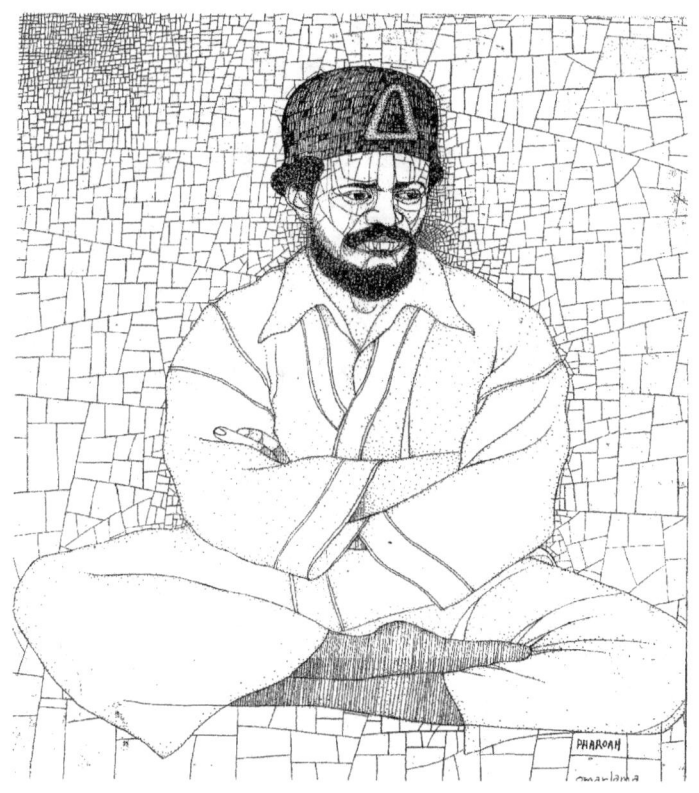

Pharoah Sanders

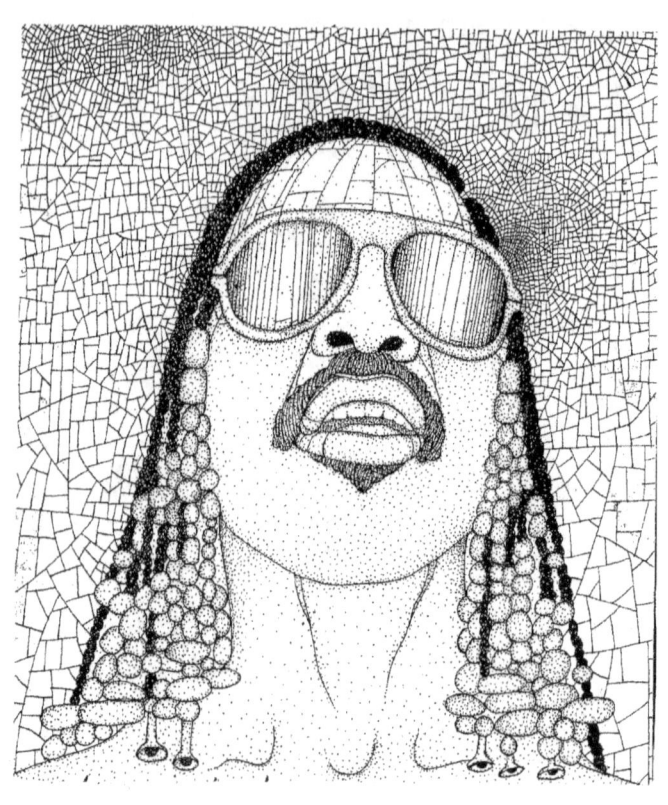

Stevie Wonder

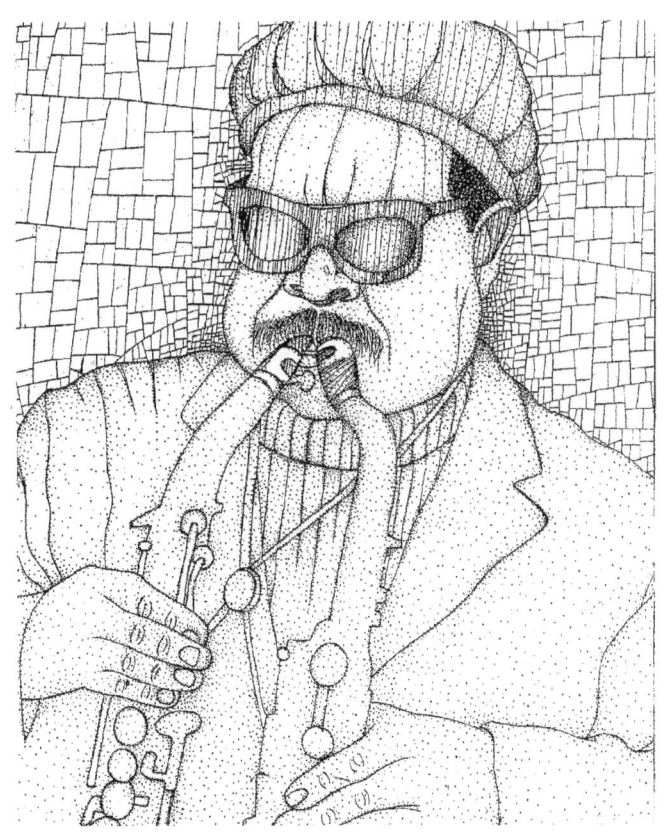

Roland Kirk

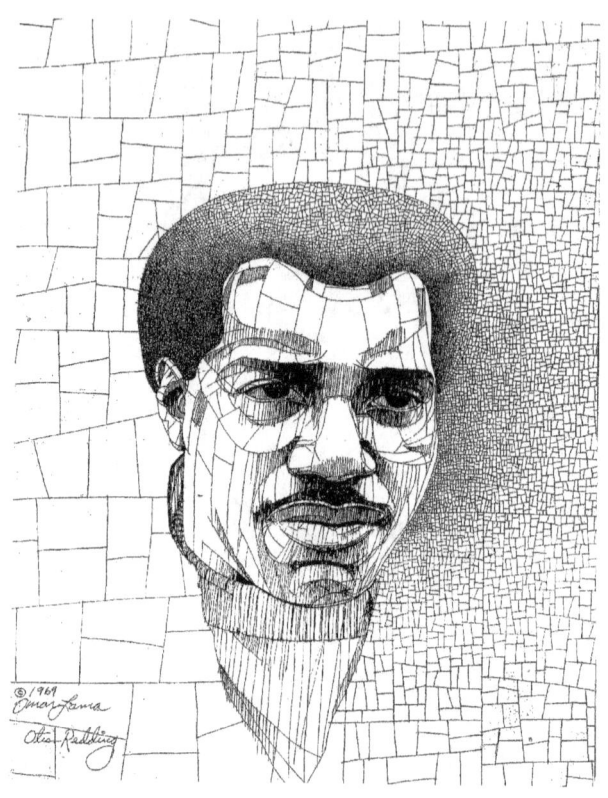

Otis Redding

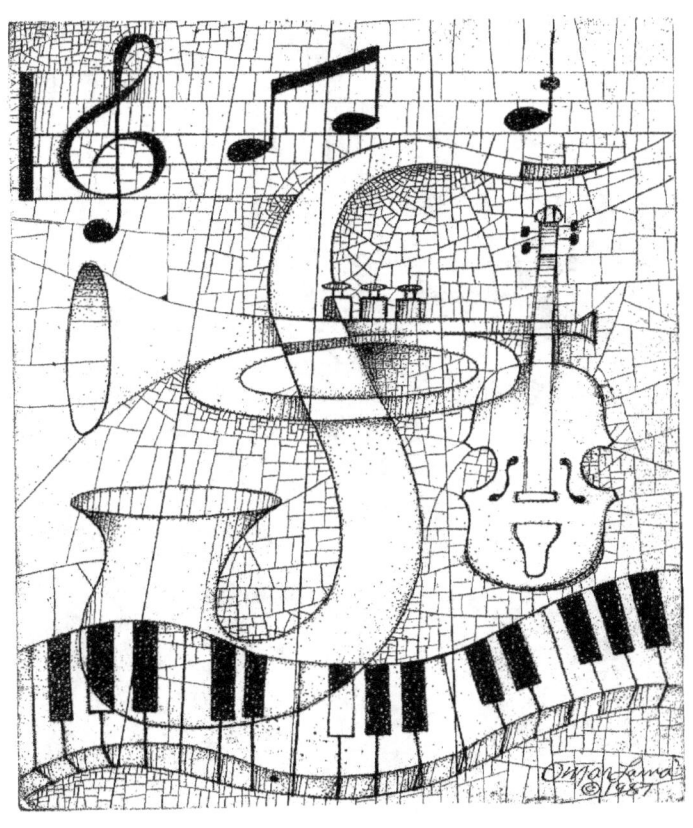

Invisible Musicians I

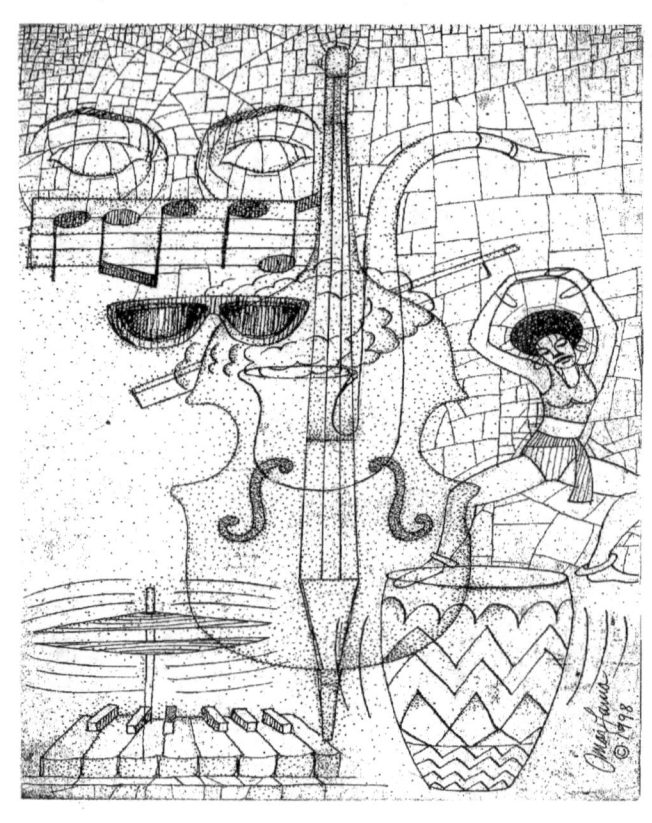

Invisible Musicians II

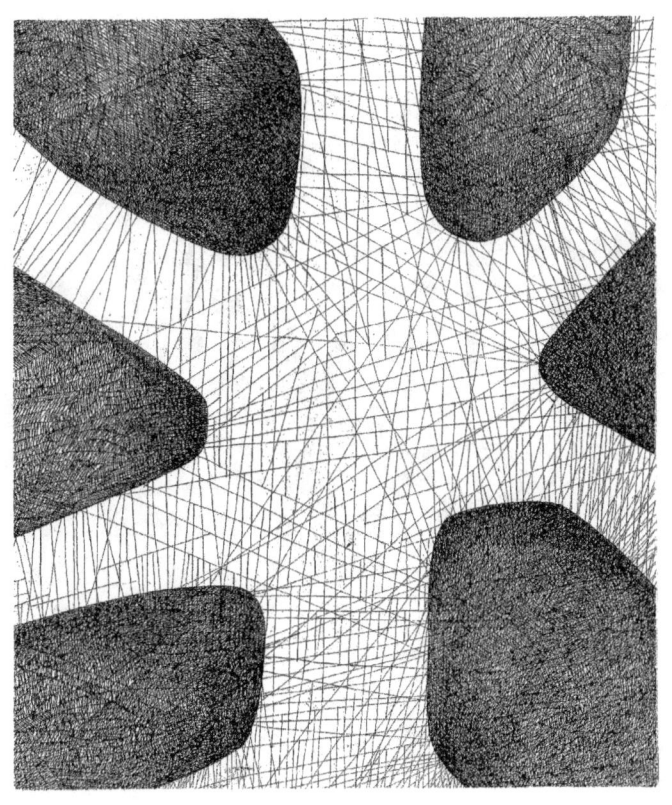

Design #1

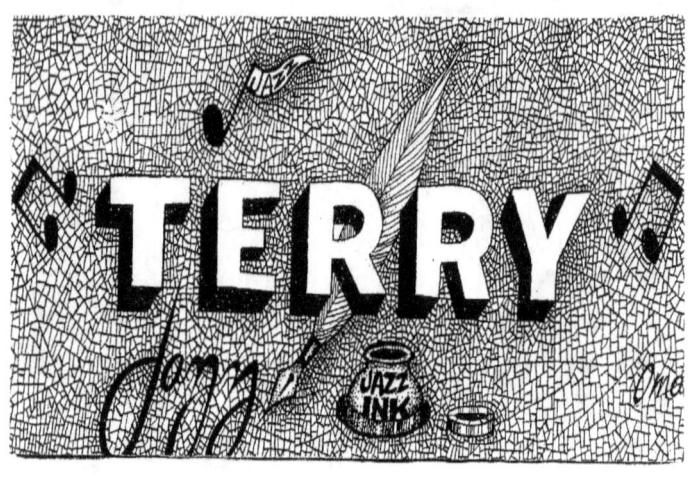

Terry the Jazzy Writer

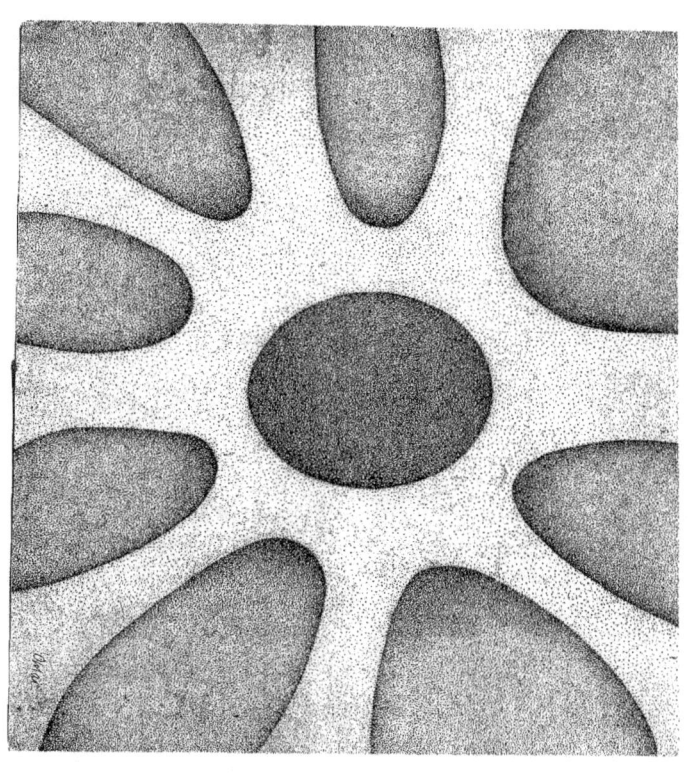

Design #2

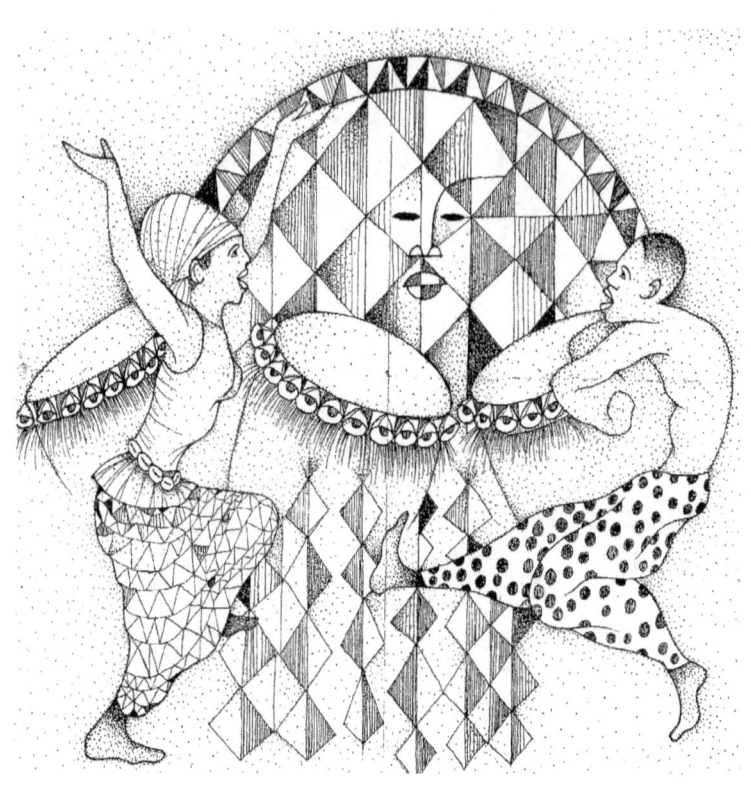

African Dance

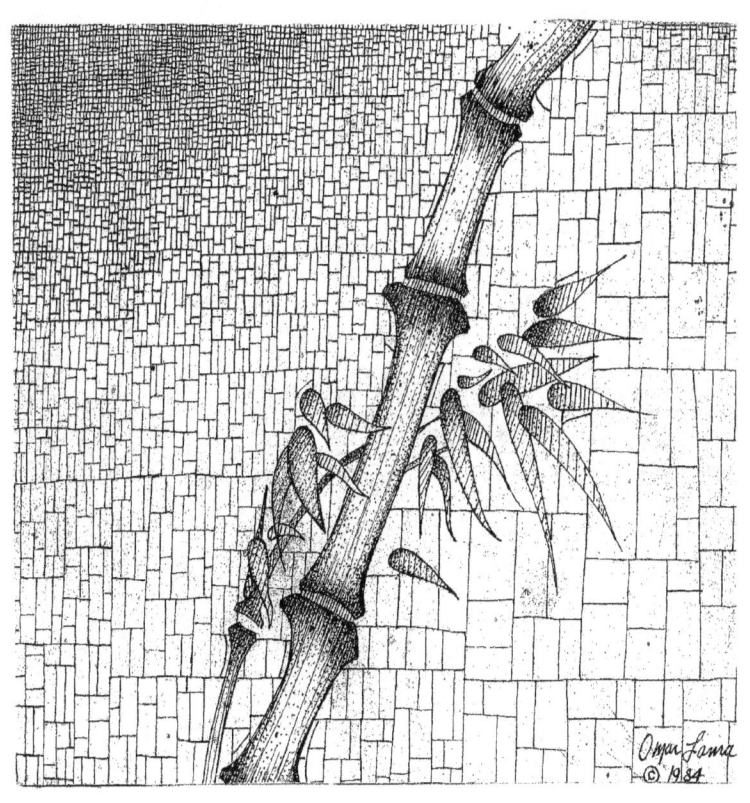

Bamboo in Wind

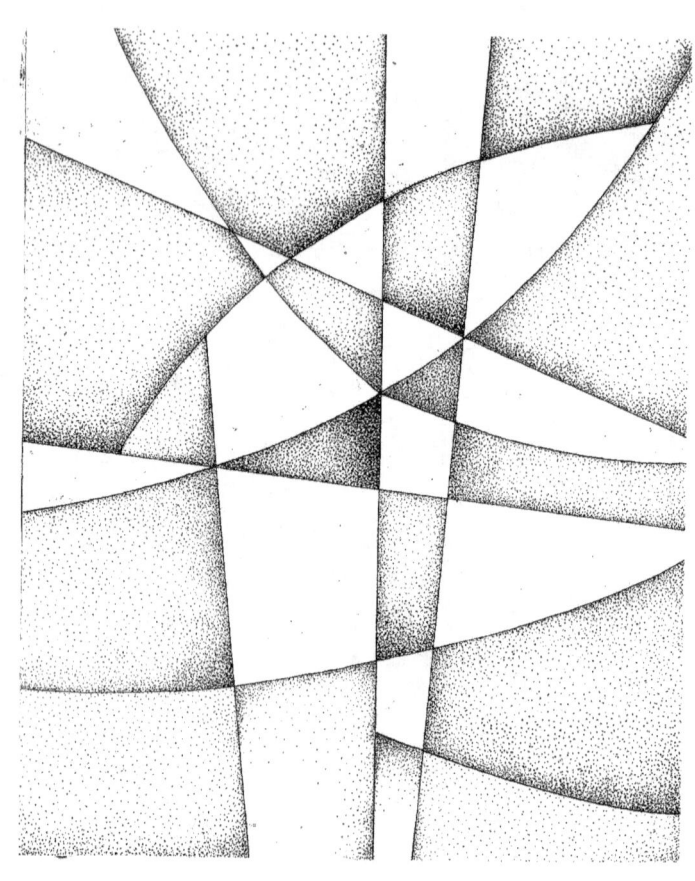

Design #56

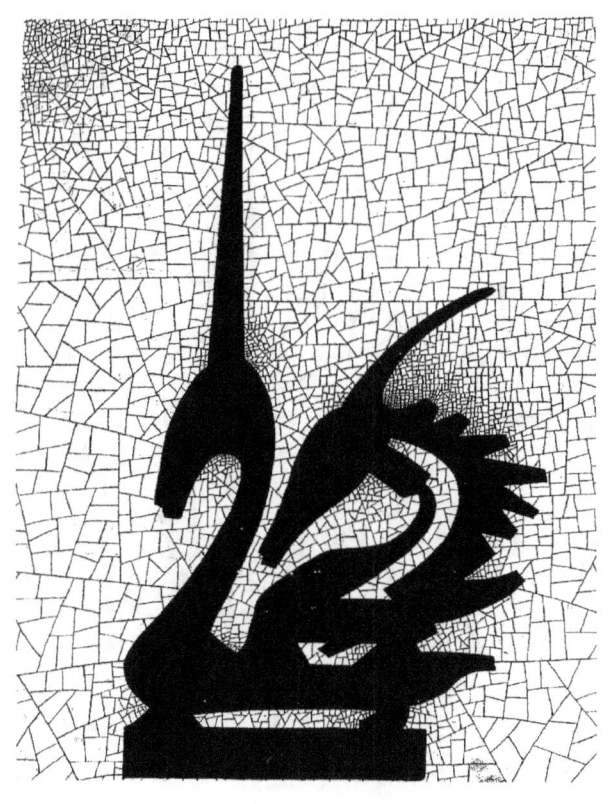

Antelope Heads

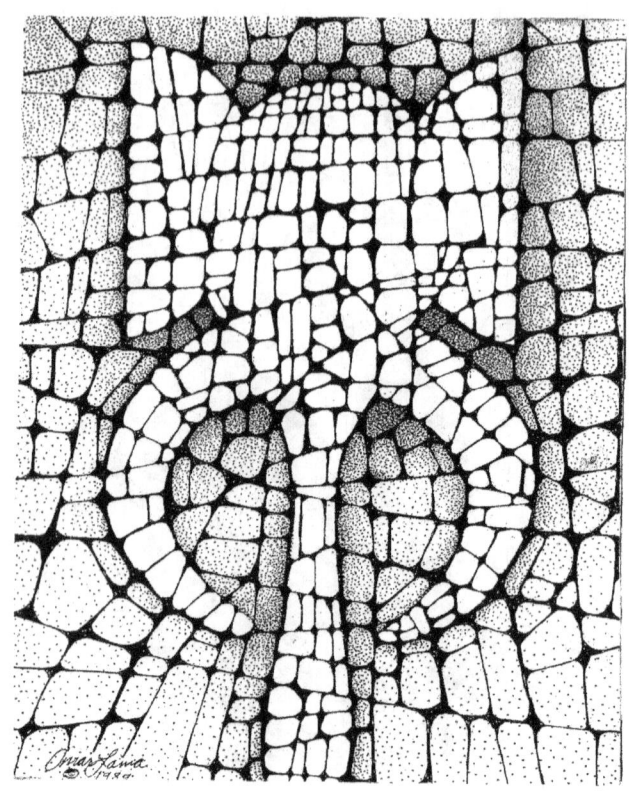

Elephant

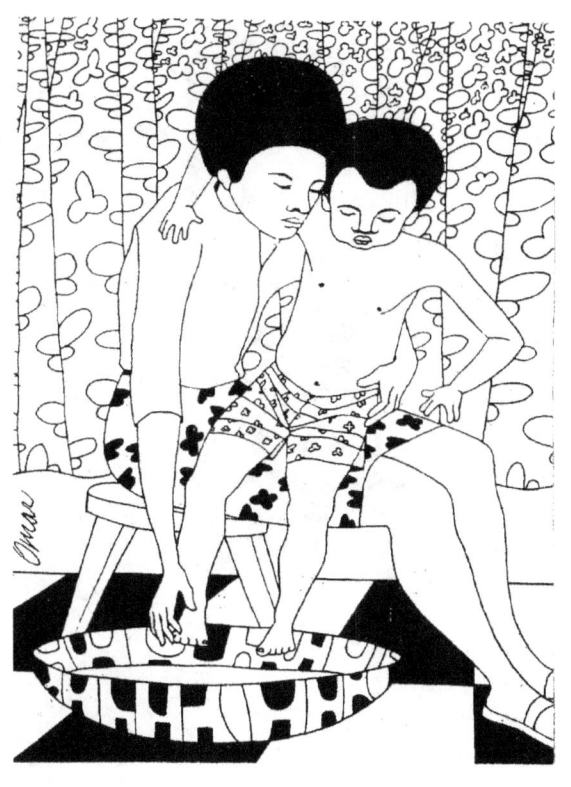

Mother and Child

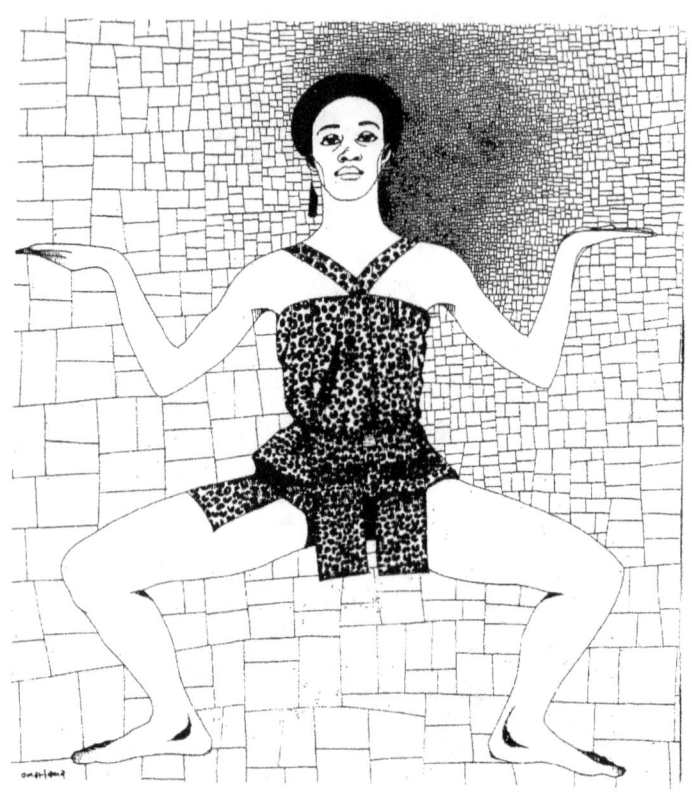

Darlene Blackburn

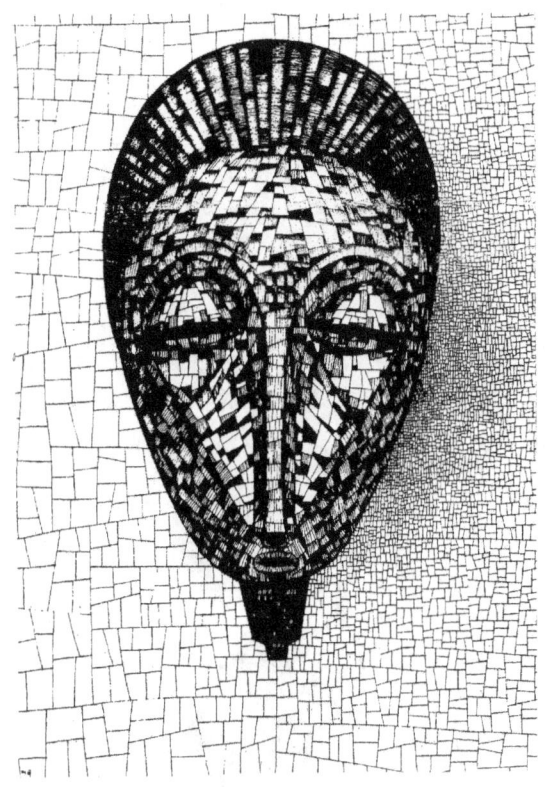

African Mask

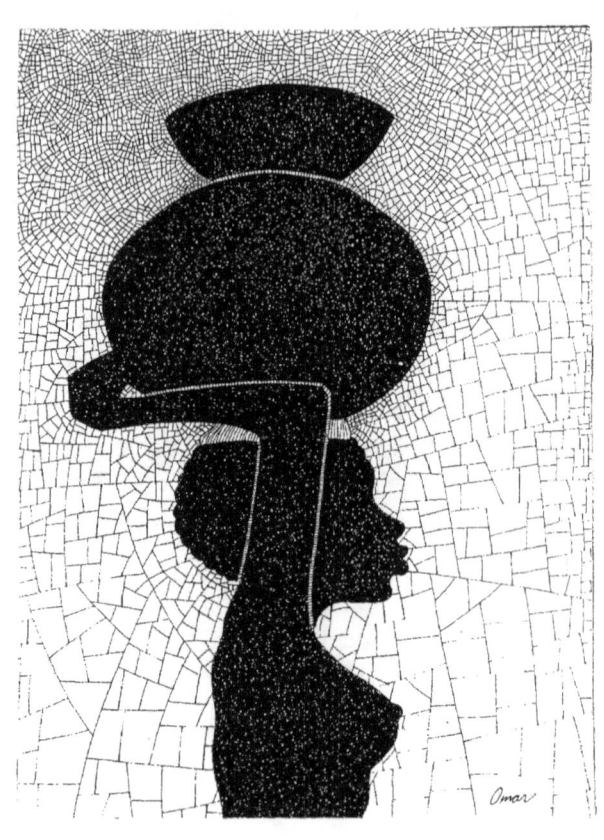

Lady with Jug

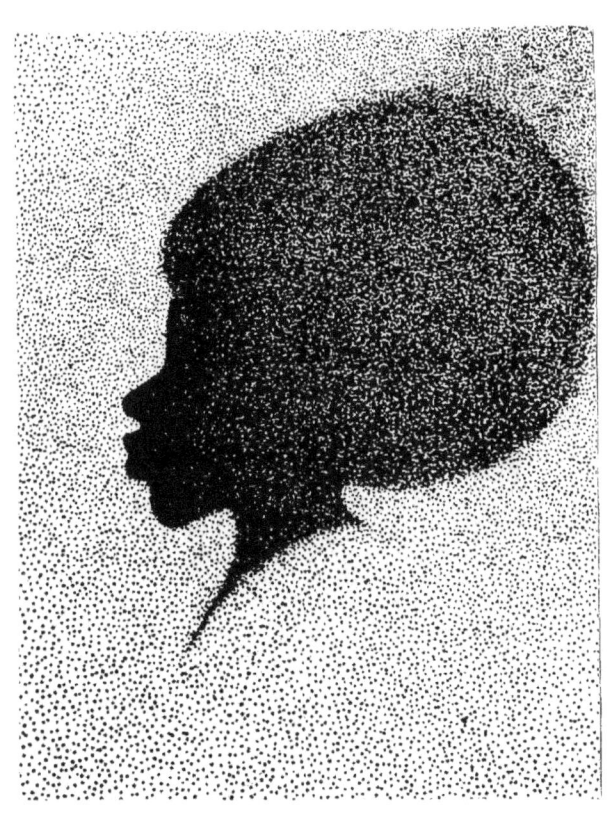

Portrait of Judy

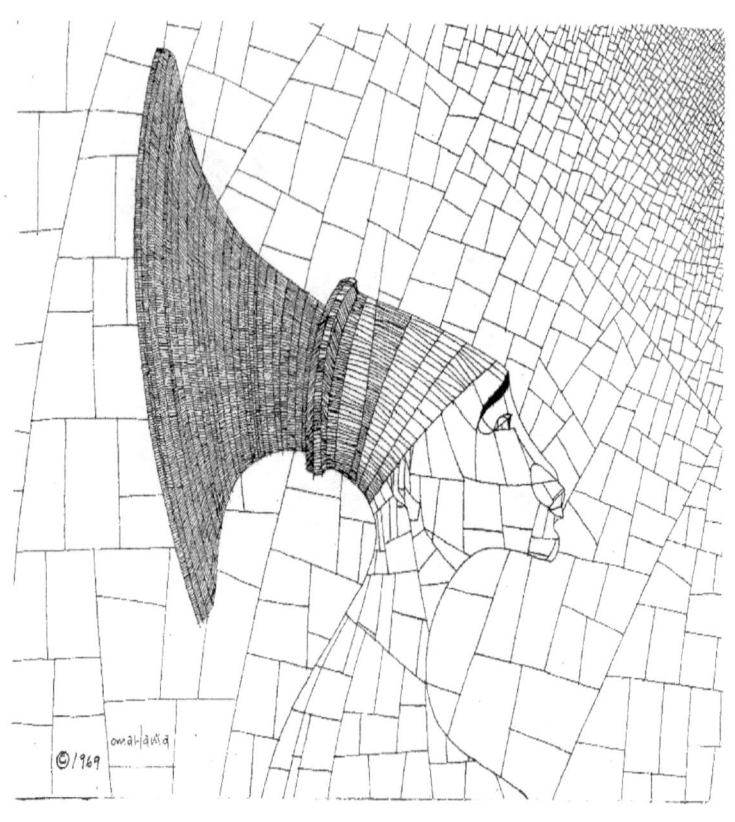

Bantu Queen

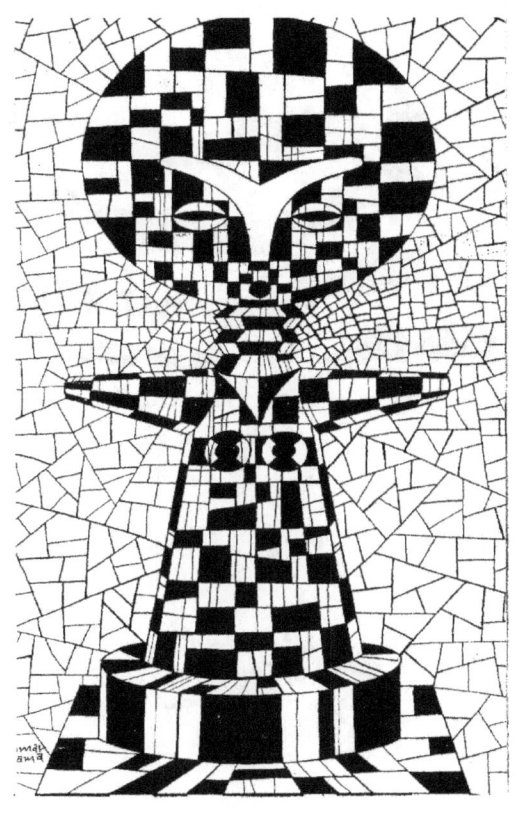

Fertility Doll #1

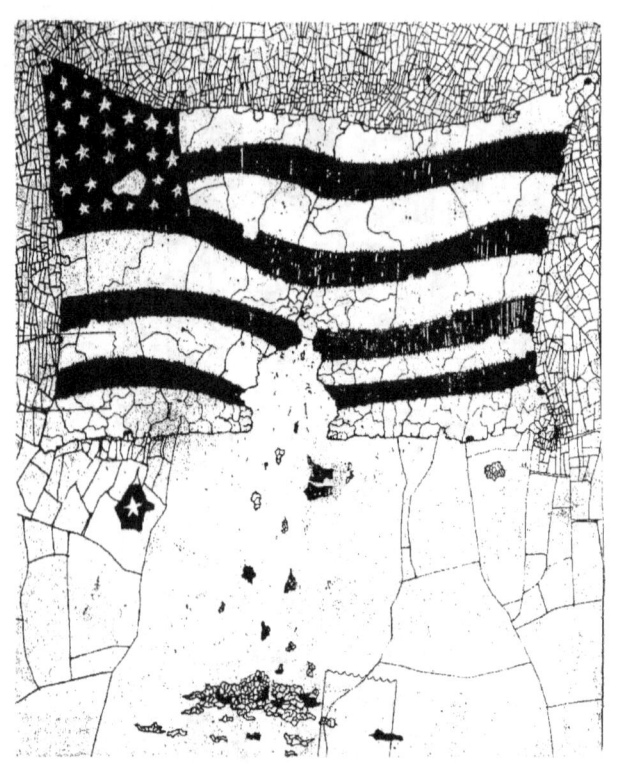

The Flag

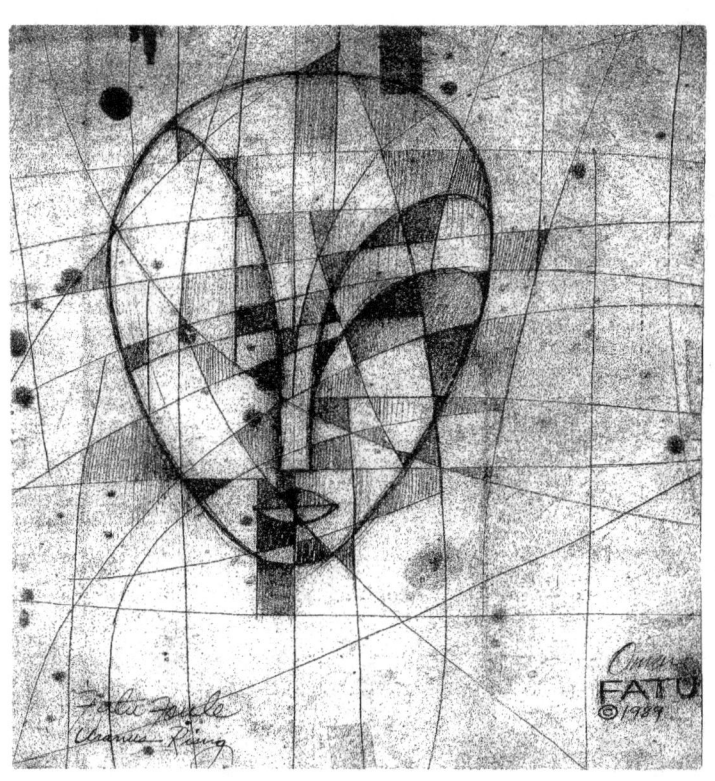

Fatu

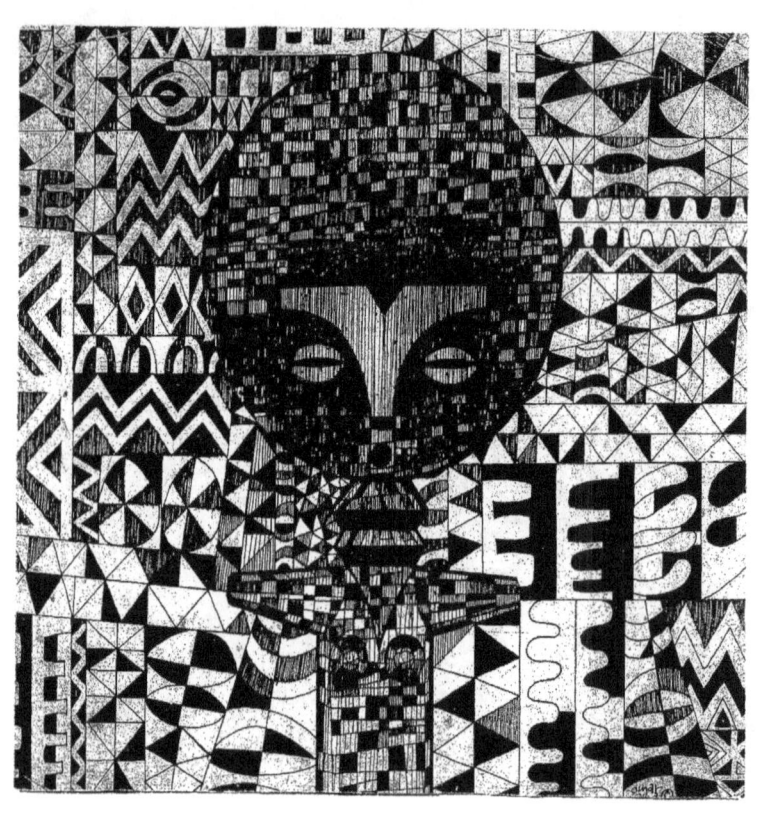

Fertility Doll #2

The Conquest of Self

THE CONQUEST OF SELF

Progress Always Depends On DISCIPLINE

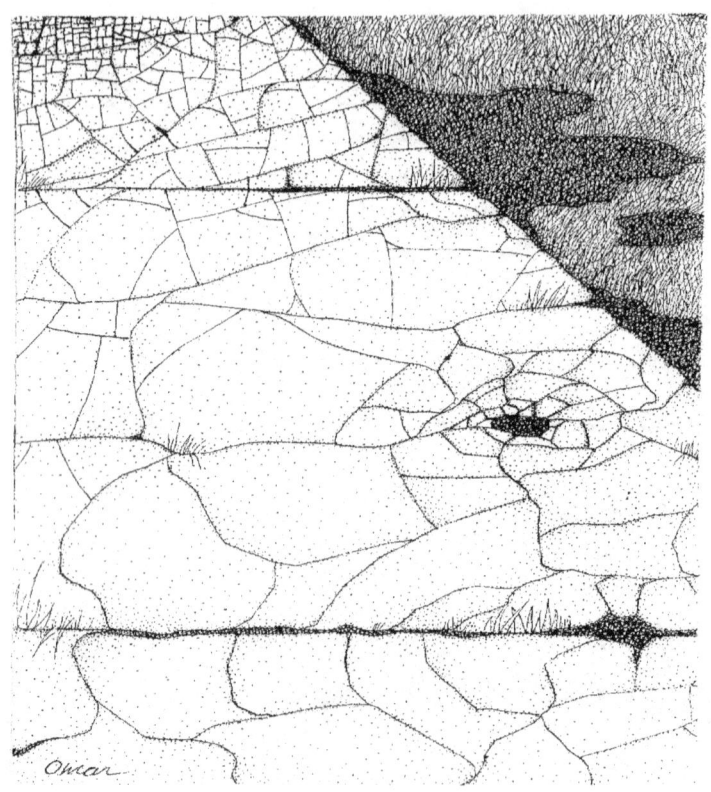

The Sidewalk

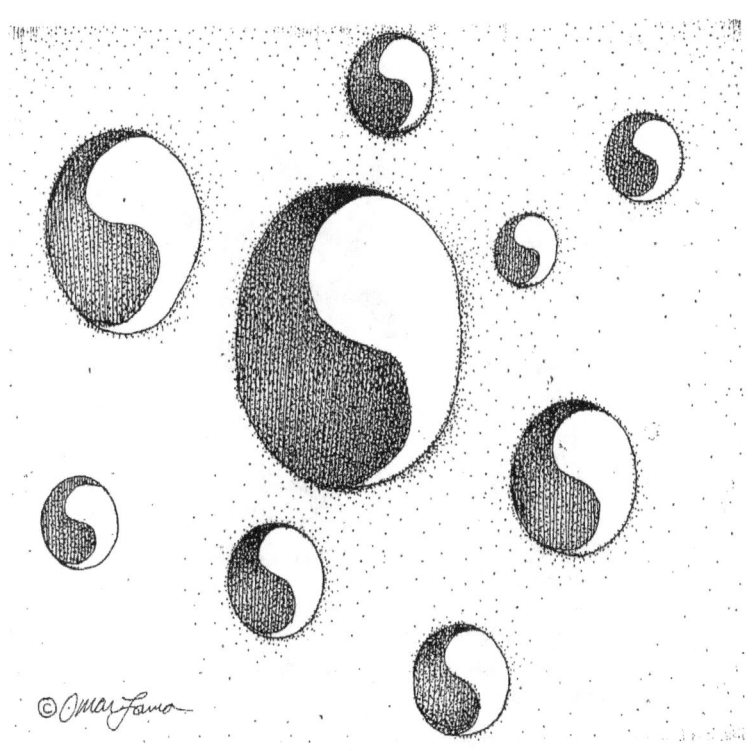

Yin and Yang

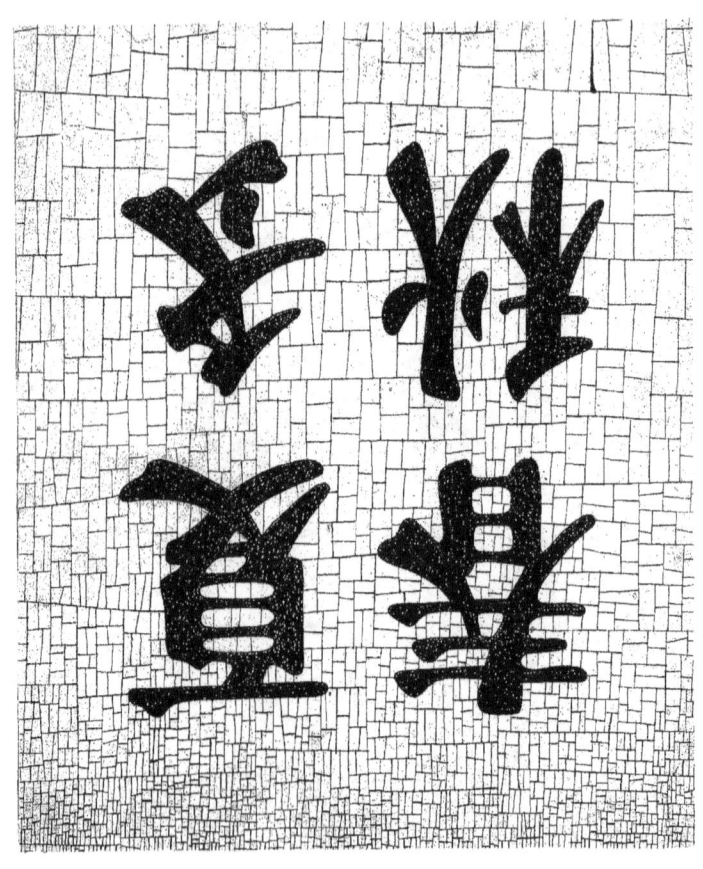

The 4 Seasons

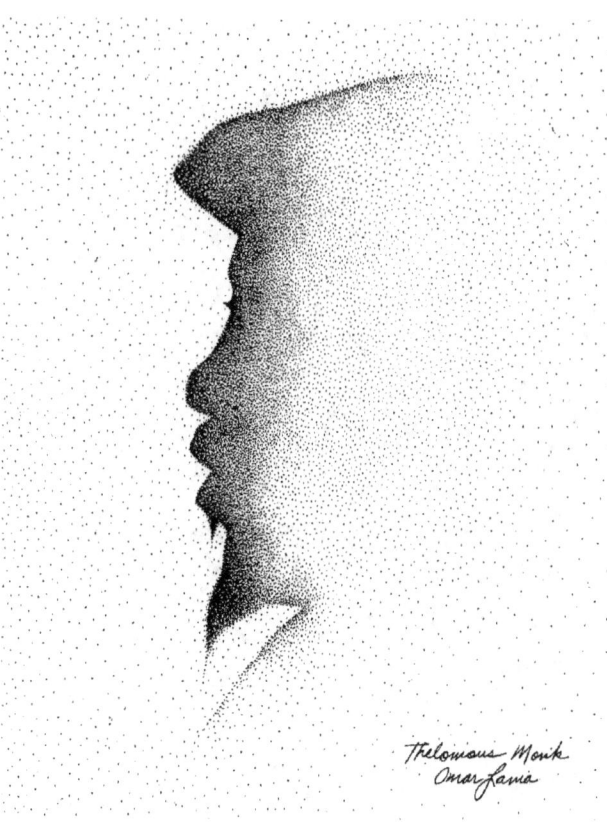

Monk

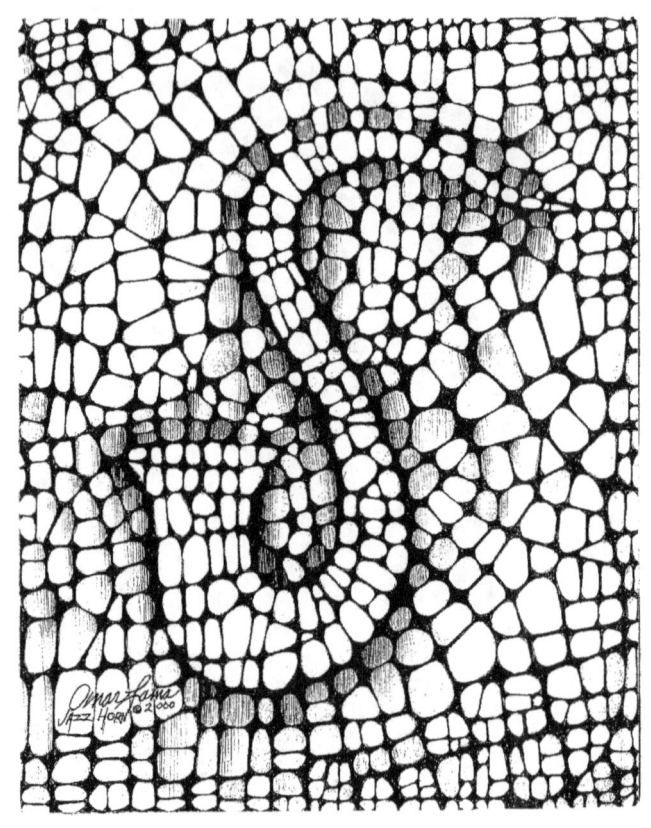

Jazz Horn

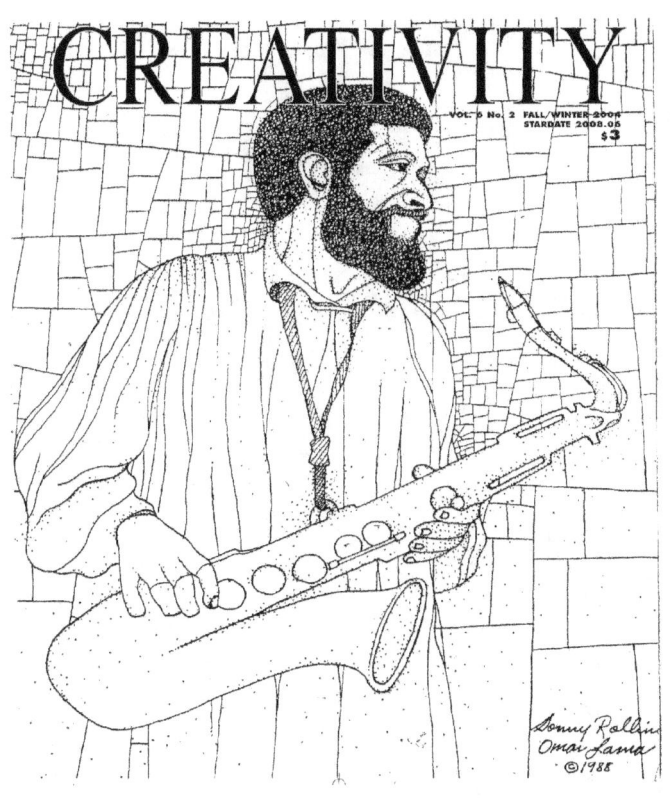

Sonny Rollins
Creativity Magazine Cover

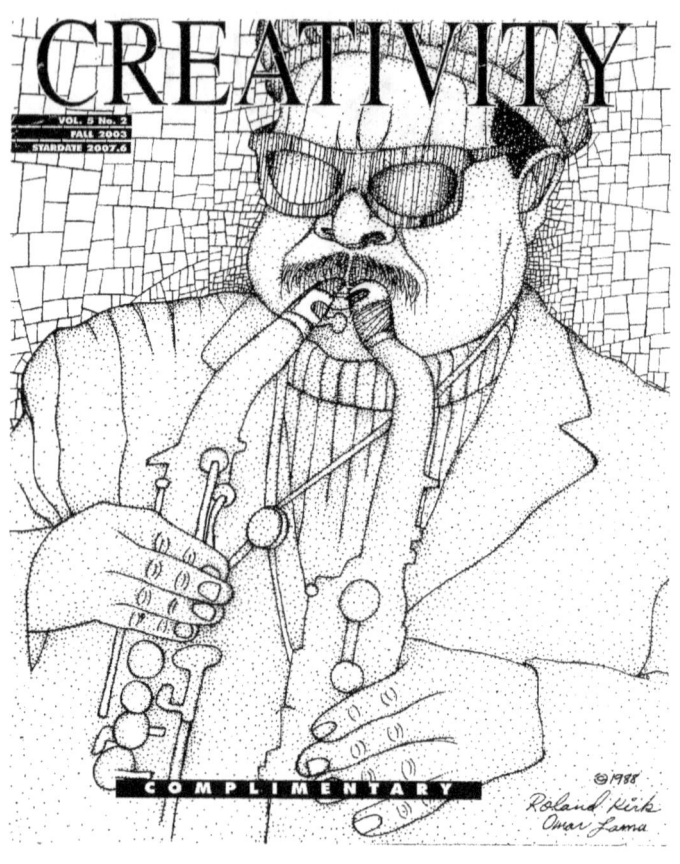

Roland Kirk
Creativity Magazine Cover

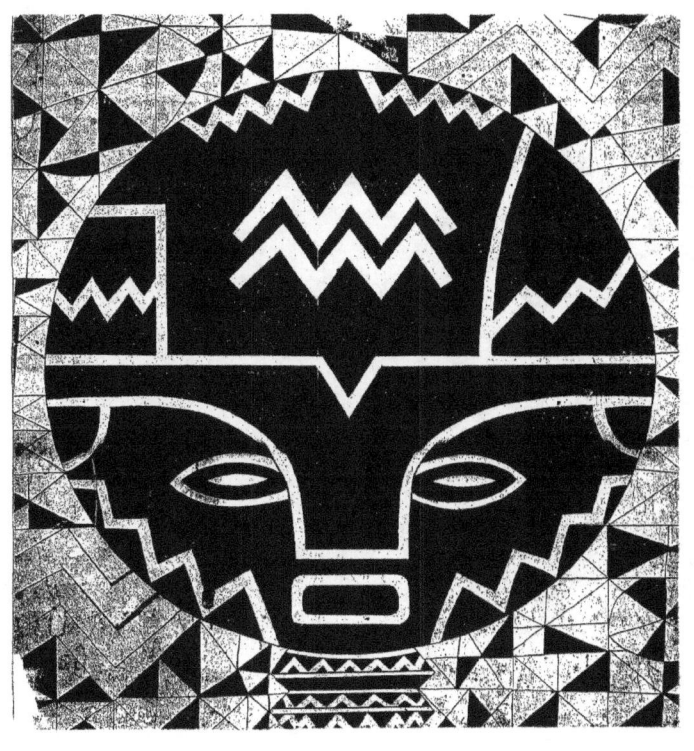

Fertility Doll #3

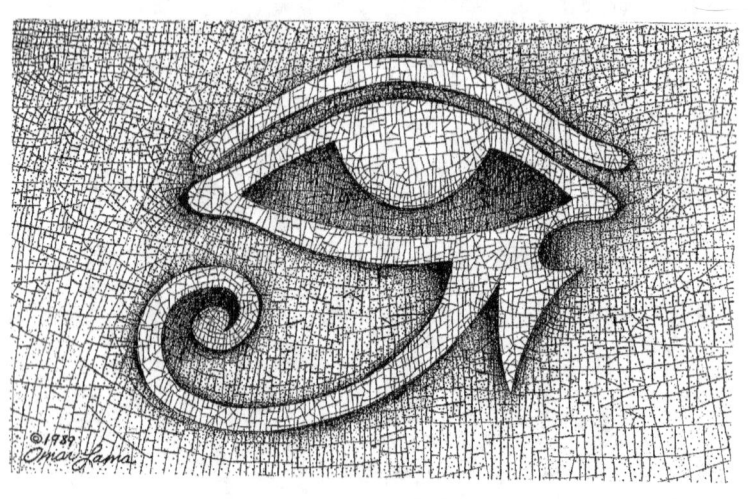

Eye of God

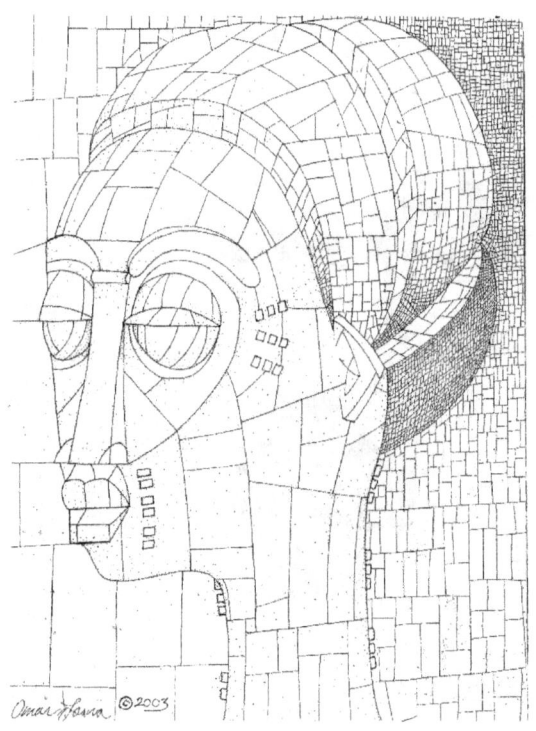

The African Head

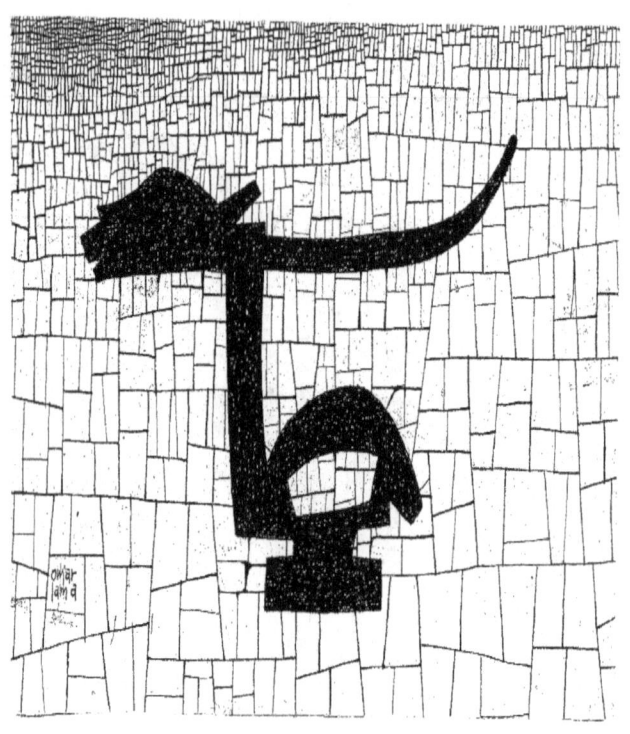

African Sculpture

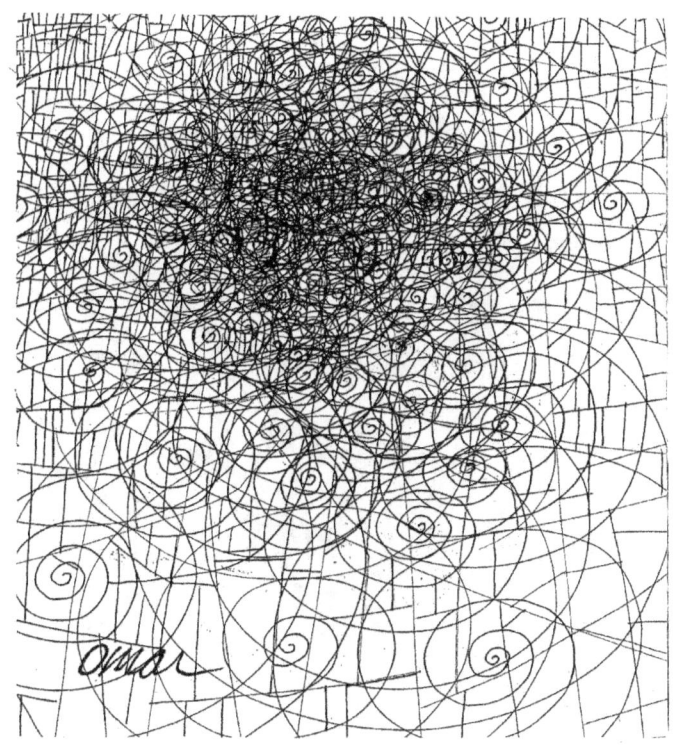

Cosmic Cycles

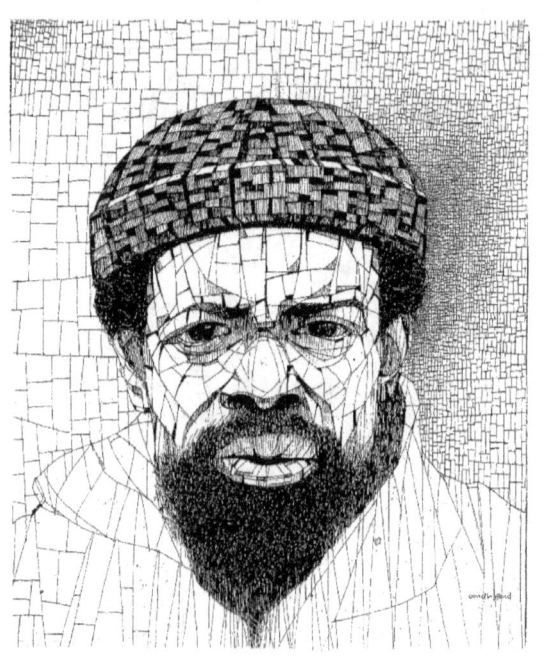

Baraka

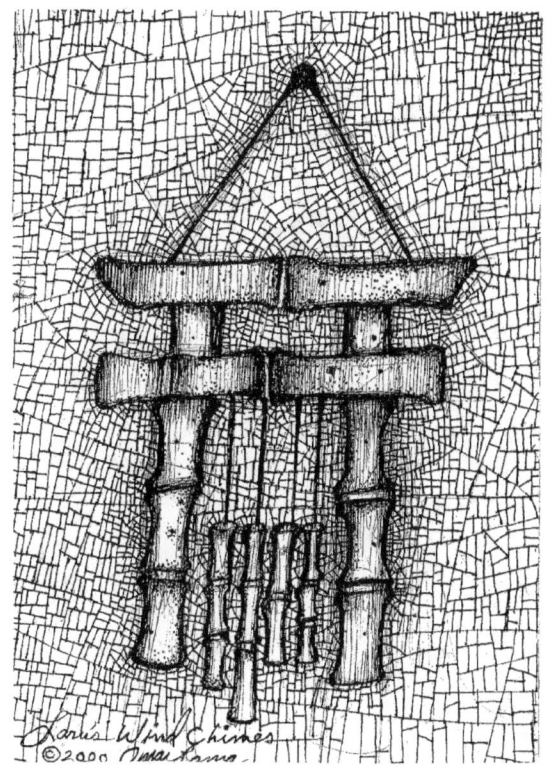

Wind Chimes

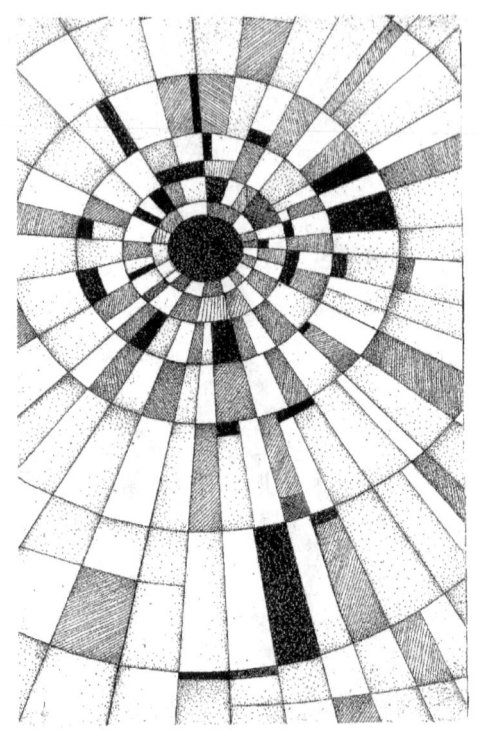

The Center

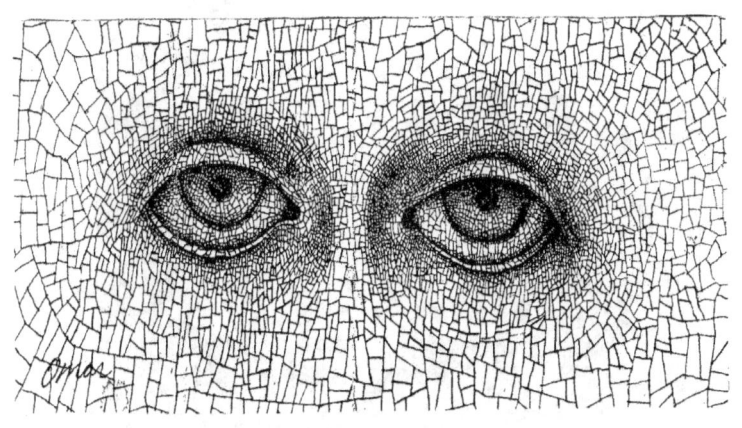

Eyes

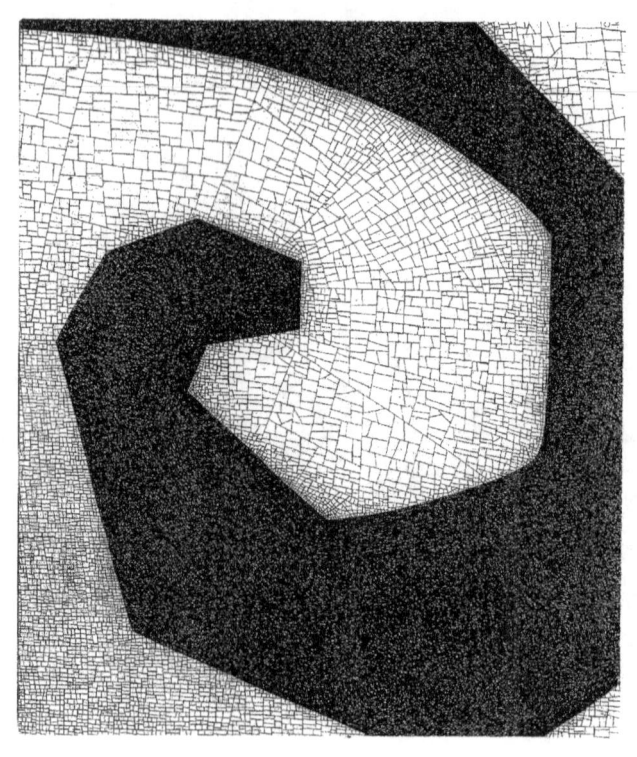

Design #13

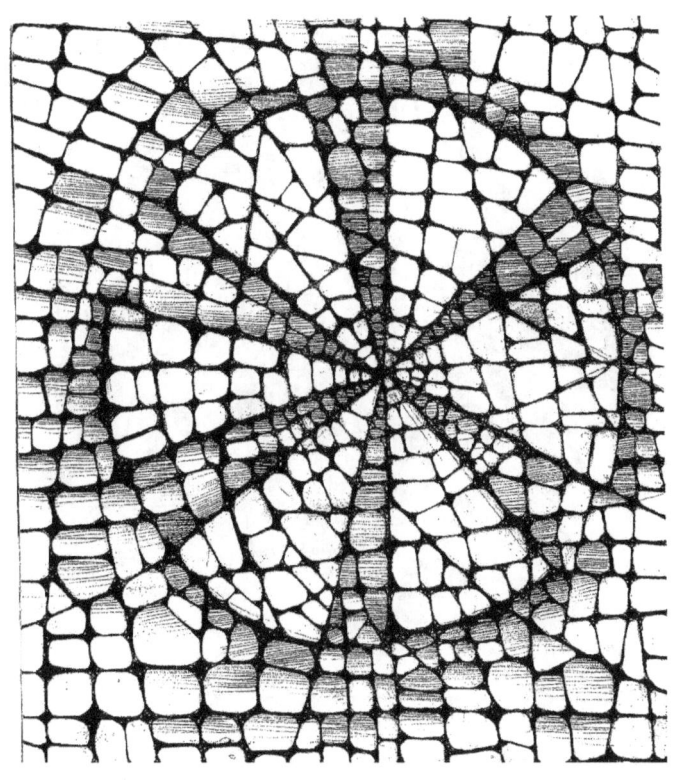

Wheel of Karma

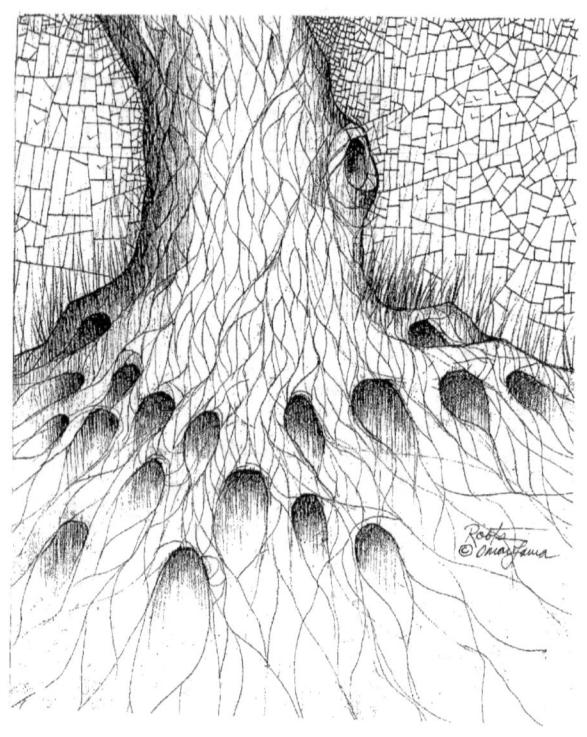

Roots

www.ingramcontent.com/pod-product-compliance
Lightning Source LLC
Chambersburg PA
CBHW071814170526
45167CB00003B/1313